LIFE LIFTERS

An anthology of words of faith, hope,
encouragements, inspirations, and insights
for dynamic living

JONATHAN T. OLAKUNLE

Order this book online at www.trafford.com
or email orders@trafford.com

jtolakunle@yahoo.com
entheosmissionnetworks@yahoo.com
www.entheosmissionnetworks.com

Cover concept by Dr. Jonathan T. Olakunle

Most Trafford titles are also available at major online book retailers.

Unless otherwise indicated, all Scripture in this book are taken from The
Contemporary English Version of the Holy Bible.

Printed in the United States of America.

ISBN: 978 1-4269-4230-3 (sc)
ISBN: 978-1-4269-4231-0 (e)

*Our mission is to efficiently provide the world's finest, most comprehensive
book publishing service, enabling every author to experience success.
To find out how to publish your book, your way, and have it available
worldwide, visit us online at www.trafford.com*

Trafford rev. 08/23/2010

 www.trafford.com

North America & international
toll-free: 1 888 232 4444 (USA & Canada)
phone: 250 383 6864 ♦ fax: 812 355 4082

Also by Jonathan T. Olakunle

Evangelism Alive
Holy Spirit in Evangelism
Jesus' Model of Holistic Evangelism
Better Things for Better Living
What you Ought to Be

<u>Life Lifters</u>

An Anthology of more than 400 dynamic short words and messages of faith, hope, courage, inspiration, insights and edification that will give your life a supernatural lifts daily

Jonathan T. Olakunle [D. Min]

Entheos Mission Networks
1694 Dean Street
Brooklyn, NY 11213,
USA

Dedication

Firstly, I dedicate this work to Father, Pa Moses Ojedokun Alabi.

I learnt so much of life lifting words, anecdotes, wise saying, biblical illustrations, and narrative stories from him.

These form the foundation for my interest in inspirations words, thoughts, pictures, and arts in my life.

Secondly, I dedicate this work to blessed memory of Dr. Norman Vincent Peale. He was an enthusiastic man of God who happened to be my mentor by proxy, and whose inspirational thoughts, insights, and words have given me much lifts in life.

Preface

The inspiration for the anthological collation of words of faith, hope, encouragement, inspiration, and insights for supernatural living came to me as a result of a gift of a Bible given to me by a church where I served as a Pastor for about two years.

The church arranged for a send-forth program for my family during which the Bible was presented to me as a gift. The Bible turns out to be a great and cherished gift to me because of the following reasons.

Dr. Norman Vincent Peale [late] wrote some inspirational messages in the Bible. I have read the celebrated book of Dr. Peale titled 'The Power of Positive Thinking'. The faith lessons in the book and in this Bible gift have been helping me in my Christian life and journey. In addition, Dr. Peale was the Publisher of a mini-size Magazine title 'Plus'. I subscribed for that magazine as far back as 1985. This Magazine has been great source of inspiration to me as well. I still have some of old copies in my shelf at home.

Life Lifters are gleaned from different inspirational thoughts and materials; Positive Thinking Bible, Plus Magazine, and other sources are inclusive in this compilation.

Jonathan T. Olakunle

It is my prayer and hope that as these thoughts are put together, it will bless the readers as they have done to me in the past and up until now.

Acknowledgement

I acknowledge the Most High God, the Creator of all things, the Ruler, Redeemer, and the Sustainer of all things. The Giver of wisdom, knowledge, understanding and strength to do all good works, to the praise and glory of his name.

I would love to acknowledge Dr. Normal Vincent Peale [late], from whose literatures I learnt many inspiration ideas and writings. I was like a member of his church in proxy.

I want to thank all who have been source of inspiration to me all my life.

Contents

Dedication .. ix

Preface .. xi

Acknowledgement.. xiii

LIFE LIFTERS—Part One ... 1

- Short Words of Faith, Hope,
 Encouragements, and Inspirations

LIFE LIFTERS—Part Two ...45

- Short Messages of Faith, Hope,
 Encouragement, and Insights with
 Scriptural references

The Book ..91

The Author..93

Part 1

- Short Words of Faith, Hope, Encouragements, and Inspirations

Short Words of Faith, Hope, Encouragements, and Inspirations

One of the greatest moments in anybody's developing experience is when he has no longer tries to hide himself, but determines to be acquainted with him as he really is.

Trust God and live a day at a time.

Learn to let God run your life; you will like the results better than your own self-management.

Do not ask a person to be what he or she is not. Do not ask or expect from a person what he cannot give.

Let God help you try. Experts are made by this procedure.

Help other people to cope with their problems, and your own will be easier to cope with.

Believe that all the resources you need are in your mind. That formula really works.

Always affirm there is an answer to any problem and that you can find it; indeed that you are now finding that answer.

Picture yourself as the kind of person you wish to be, affirm that you are that, and then practice being it.

Do your best and leave the results to God.

At least ten times every day affirm, "I expect the best, and with God's help will attain the best".

Pray big; God will grant big things if you ask for them and are big enough to receive them.

Faith is the most powerful of all forces operating in humanity, and when you have it in depth, nothing can get you down. Nothing!

People become really quite remarkable when they start thinking that they can do things. When they believe in themselves, they have the first secret of success.

A clean mind always delivers power.

Realize that you can, of yourself, do much to make yourself a healthy and alive individual.

Miracles come in all sizes. In addition, if you start believing in little miracles you can work up to the bigger ones.

It's always too soon to quit.

Stress the thought of plenty. Thoughts of plenty help create plenty.

The relax person is the powerful person.

If there is no fun in it, something is wrong with all you are doing.

Faith plus dynamic dreams plus real working at it is a go-ahead formula that gets you where you want to go.

Becoming a specialist in doing the "wholly impossible", the things that "can't" be done.

Take pleasure in the pattern of the sunlight falling through the trees or the sound of the crunch of snow under your foot. Relish these things which are the essence of life and they will make your heart sing within you.

There is only one real security in this world, only one; identification of the soul with the ultimate reality—God, our Refuge and Strength.

Understanding can overcome any situation, however mysterious or insurmountable it may appear to be.

Drop the three L's- Lack, Limitation, and Loss – from your vocabulary.

Never think down—always think up.

There is a giant in every person and nothing can get this giant down unless that giant is kept down by himself.

Cultivate willpower, that massive creative force that God the Creator built into you. Do not let it remain flabby, but strengthen it by use and exercise.

Ten times each day practice the following affirmation, " Christ gives me strength to face anything" [Philippians 4:13]

To be rid of worries about past mistakes, repeat this daily, "forget what is behind, and I struggle for what is ahead. I run toward the goal, so that I can win the prize of being called to heaven" [Philippians 4:13,14]

Why be defeated when you are free to draw upon a higher power that can do everything for you?

Commit the following statement to memory and say it now and then; " I asked the Lord for help, and he saved me from all my fears" [Psalm34:4]

The world in which you live is not primarily determined by outward conditions and circumstances, but by thoughts that habitually occupy your mind.

If you are not of enthusiasm, get reborn spiritually. That experience will make you come alive.

Master the perception principle. Learn to know yourself. Know the real person deep within you.

Our happiness depends upon the habit of mind we cultivate. So practice happy thinking every day.

Cultivate the merry heart, develop the happiness habit, and life will become a continual feast.

Cut the "im" out of possible, leaving that dynamic word standing out free and clear –possible.

Two great forces operate in the mind; fear and faith. Fear is very powerful, but faith is more powerful.

Saturate your thoughts with peaceful experiences, peaceful words and ideas and ultimately you will have a storehouse of peace—producing experiences to which you may turn for refreshment and renewal of your spirit.

Keep alert to the magic motivational word that forms an inspiring idea for you. It can reactivate and change you from indifferent to dynamic living.

The way to happiness:

1. Keep your heart free from hate.

2. Live simply.

3. Expect little give much.

4. Fill your life with love.

5. Scatter sunshine

6. Forget self, think of others

7. Do as you would be done by.

Try this for a week and you will be surprised.

How do you keep enthusiasm? —Form a mental picture of the goal you wish to attain, and another picture of that goal as being achieved, and you have put wings under the hard toil of trying.

Stand up to any defeating lack thoughts and tell them to get out of your mind.

Knowledgeable persons now recognize the validity of spiritual principle as verifiable scientific procedure. They know that power operates through the mind as surely as it moves through wires and, that faith produces results.

God helps those who help themselves. So the best very to be sure that God will take care of you is to take pretty care of yourself.

While fear thoughts can destroy greater capacity, and bring to pass things that are constantly feared, faith and positivism can create and develop.

Practice the positive principle—the principle of the possible[Mat.17:20]

Always let your prayer take the form of thanksgiving on the assumption that God is giving you great and wonderful things; for if you think He is, He surely is.

Do not shy off real spiritual faith. It is packed with excitement that burns out boredom.

See how many people you can help to cure their own worry habit. In helping another to overcome worry, you get greater power over it within yourself.

The Creator built energy into you and me when we were babies. He implanted in us the life force, and true faith can keep this life force alive.

Contact with God establishes within us a flow of the same type of energy that re-creates the world and renews springtime every year.

Watch your manner of speech if you wish to develop a peaceful stable mind. Start each day by affirming peaceful, contented, and happy attitudes and your days will tend to be pleasant and successful.

Act as if you had enthusiasm. Believe

that you have it and you will be enthusiastic.

The tests of life are not to break you but to make you.

Every morning before arising, lie relaxed in bed and deliberately drops happy thoughts into your conscious mind.

The right way is right, because it meets less resistance and is therefore easier than the wrong way.

If anyone followed the purpose of the Creator, the general thrust of life would be in our favor, though not without some hard going at times.

Do not always ask when you pray but instead affirm that God's blessings are being given, and spend most of your prayers giving thanks.

Ask for what you want, but be willing to take what God gives you. It may be better than what you ask for.

One can impel his personality powers into action by intense desire, intense belief, and intense prayer—"intense" differentiating these factors from the usual blend attitudes of so many.

The truth is that there is much more strength and power in the individual than he has ever known or even visualized as a possibility.

Make a mental list of happy thoughts and pass them through your mind several times every day.

Remember that while the doctor treats you, God heals you.

Never think you "harvest a prayer". You do have a prayer to carry you through.

The more you venture to live greatly, the more you will find within you what it takes to get on top of things and stay there.

There is a reason why you do what you do and it is an important day in your life experience when at last you discover the reason. Self-knowledge is the beginning of self-correction.

Never bog down in a defeat psychology. Always in the midst of defeat, keep looking for victory.

Listen for the magic word of motivation and you will hear it. Then the sky is the limit.

Constantly reemphasize the great fact that God built potential strength into your nature. By affirming it and practicing it, this basic strength will toughen up as muscles do.

Whatever you do, do not make all your prayers into the form of asking God for something. The thanksgiving is much more powerful.

You can if you think you can. Engrave those seven words deeply in consciousness. They are packed with power and truth.

Get out of your way to talk optimistically about everything.

Rid yourself of all sick thoughts—hates, resentments, inferiority, and the like.

Practice excited thinking until you become excited—and exciting.

Do not tense up, for you only close off creative power when you do. Organize your difficulties and problems. Then you will have half the solution and the rest will come more surely and easily.

The positive thinker constantly sends out positive thoughts, together with vital mental images of hopes, optimism and creativity. He therefore activates the world around him positively and strongly tends to draw back to himself positive results.

Only a few of those who accomplish things in this world are super-intellects. However, they have one super quality that keeps them growing: the I—will—keep—trying—attitude.

Remember, Edison's remark;"If we did all the things we are capable of doing we would literally astonish ourselves". Astonish yourself.

The magic of enthusiasm can work magic in your life: Its powerful effect can remake your very existence.

Eliminate the word "impossible" from your conversation, drop it from your thoughts, and erase it from your attitudes. Stop rationalizing it. Cease excusing it. Substitute for it that bright and shining word "possible".

Let the challenge of your ambitions, of your aspirations; rouse your slumbering and often unused powers into action.

Thoughts and words form your mental image. Moreover, since we become what we picture, be sure your thoughts and words express prosperity and blessing rather than poverty and defeat.

The secret of prayer is to find the process that will most efficiently open your mind humbly to God. So experiment with fresh prayer formulas. Practice new skills and get new insights.

Only the believers pick up prizes in this life.

Be humble. Be big in mind and soul. Be kindly. You will like yourself that way and so will other people.

To help reduce tension, practice the peace of God, which surpasses all understanding. Then note the quiet power that wells up within you.

Prayerize, visualize, energize, and actualize.

Those who are fired with an enthusiastic idea and who allow it to take hold and dominate their thoughts find that new worlds open for them. As long as enthusiasm holds out so will new opportunity.

Take a long straight look at your fear. Know it for the ghostly thing it is and stand firmly up to it. Then practice strong action.

If you love people, you inevitably get back love in return and thereby experience a joy that makes you a happy person.

Those great hopes, dreams, and ideals of yours are not dead, if you let God breathe into them the breath of fresh life.

You can if you think you can. As you think, so shall it be. Then think you can and you can, indeed.

Never react emotionally to what happens, but always look for and find in every circumstance the good that is surely present there.

Keep the positive principles going by visualizing energy and vitality continuously at work within you, refreshing body, mind and spirit.

Keep alert for those flashes of insight that come when you are really thinking.

As you develop and hold the thought that any adversity can actually be turned to your advantage, you then have an immense mental asset going for you.

Say to you, "worry is just a very bad mental habit. And I can change any habit with God's help".

Get away from dirty and noisy cities. Get with streams, meadows, mountains if it is all possible. Nature siphons off boredom.

Through study and practice, develop intensity of belief, in-depth faith, as contrasted with the nominal variety.

Know that you are yourself a miracle. In addition, believe you can make miracles happen—by [1] thinking [2] praying [3] believing [4] working and by [5] helping people.

To drop tension from your life, practice getting tranquility by passing peaceful words and thoughts through your mind daily and nightly. They have a healing quality.

Add the thought of all elements of the body working together in perfect rhythm.

Do not write off the importance of hard work, the guts to keep at it, a definite goal and the ability to have fun in the process. If there is no fun in it, something is wrong with all you are doing.

God has arranged two remedies for all illness. One is healing through natural laws applicable by science and the other brings healing by spiritual law applicable through faith.

Visualize the kingdom of God as in you. See yourself as the potential possessor of God's bounty.

Do your honest best, think prosperity and the Lord will, for a fact, provide. He will do the providing through you.

To be successful is to be helpful, caring, and constructive, to make everything and everyone you touch a little bit better. The best thing you have to give is to give yourself.

No difficulty is impregnable. Even imaginary ones can be overcome by right thinking.

Instead of trying to destroy all your anger, snip away by prayer each annoyance that feeds your anger. In so doing, you will weaken it to such a point that you will have control over it.

Take the best into your mind and only that. Nurture it, concentrate on it, visualize it, pray over it, and surround it with faith. Make it your obsession. Spiritually creative mini-power, aided by God's power will produce the best. Never start a day or any job without praying about it. You will get some of your best ideas that way.

The chief struggle in gaining mental peace is the effort of revamping your thinking to the relaxed attitude of acceptance of God's gift of peace.

Be all-out, not hold-out.

Do not waste mental energy brooding over past events or worrying about the future. Live a day at a time and do a job at a time.

As you think defeat, you tend to get it. Instead, adopt the "I don't believe in defeat" attitude.

Never forget that all the enthusiasm you need is in your mind. Let it out. Let it live. Let it motivate you.

God's peace deeply imbedded in your mind can often have a more tranquilizing and healing effect upon nerves and tension than medicine. God's peace is itself medicinal.

The formula that will bring your cherished wish to pass is – [1] To know what you want [2] To test it to see it is right thing [3] To change yourself in such a manner that it will naturally come to you and [4] To always have faith.

You can reach your goal... Your best dreams can come true... You can get where you want to go... only if you know what your goal is.

When uncontrolled, your mind can be very damaging to you. However, when controlled it can develop unlimited power.

Stress the thought of plenty. Thought of plenty help create plenty.

Never think of failure. You do not need to!

Every day remind yourself of your ability, of your good mind, and affirm that you can make something good out of your life.

If you consider yourself weak and inadequate, you are making an enormous view. Know for sure that there is a giant within you. Then release the giant you.

When you actually learn to release the potential power of your mind, you will discover that it contains ideas of such creative value that you need lack anything.

Give thanks daily for your blessings... Get into the habit of thinking happy thoughts... Go out of your way to make other people happy... that is the formula for real happiness and enthusiasm.

Select a few people to be particularly kind to today, those you were a little harsh with yesterday.

Do not spurn God's help, for He has broad shoulders, strong arms and wonderful ideas.

Keep thinking about your fears being drained out of your mind; those thoughts will in due course be actualized.

Never participate in a worry conversation. Shoot an injection of faith into all your conversations.

Formulate a goal; not a fuzzy, vague goal, but one that is sharp, clearly defined and specific. Pray about it. Hold the image until it sinks into the unconscious. Then give that goal all you have got in thought, effort, imagination and innovation.

The secret of changing one's personality, regardless of problems is to think in new categories, re-educating your thought pattern so that enthusiasm is put into the top-priority category.

Feed your mind with thoughts that cause it to be peaceful. To have a mind full of peace, merely fill it full of peace, it is as simple as that.

Prayer can freshen you up every evening, Send you out renewed each morning. It releases and keeps power flowing. It seems able even to normalize the aging process.

We are not meant to be worms crawling defeated in the presence of a difficult situation. We are children of God who can take charge of our thoughts and do what we will with them.

As you develop and hold the thought that any adversity can actually be turned to your advantage, you then have an immense mental asset going for you.

Never let any mistake cause you to stop believing in yourself. Learn from it and go on.

Hold the image of the life you want and make the image become fact.

Never allow sick attitude to poison your thinking, nor let ill will make you ill. Avoid making your mind "sore" by that painful reheating called resentment.

If you sit, relax, get yourself in tune with God, and open yourself to the flow of His power, then sitting is not laziness; in fact, it is about the best way to renew power.

Never react emotionally to criticism. Analyze yourself to determine whether it is justified. If it is, correct you, otherwise, go on about your business.

You will never know what great things you can do until you try—really try.

Believe that you are bigger than your difficulties, for you are, indeed.

Practice failure and you can quite surely count on failing. Practice enthusiasm in even the most commonplace things and presently the immense power of enthusiasm will begin working wonders for you.

The conscious mind may suggest success, even death, but nine-tenths of your mind is in the subconscious. Let the picture of health sink into the subconscious, and this powerful part of your mind will send forth radiant health energy.

When you are in an upsetting situation, try loving everyone involved and pray for him or her, hard as that may be. Loving does not mean sentimentality; it is a rational esteem for their value as person.

Empty out all old dead thoughts and be reborn in mind and spirit. That experience will make you come alive.

Always remember that problems contain values that have improvement potentials.

The negative principles negate... The positive principles create... The negative principles doubt... The positive principles believe... The negative principles accept... The positive principles go for victory...

Visualize God, who created you, as constantly re-creating you in every element of being.

What you think, you will become

—good or bad

—weak or strong

—defeated or victorious;

So practice being a positive thinker.

Go to sleep using the conscious thought and affirmation that whatever you may be called upon to handle the next day, God and you will be able to do together.

Motivation is like nutrition. It must be taken daily and in healthy doses to keep it going.

God wants to give you great things, but even he cannot give you any greater blessing than you can believe.

Never force a decision. Let it simmer. If you properly condition the mind, the decision will emerge when completely done.

Do not see yourself as old—and getting older. Live youthfully now—and always.

When a hurt feeling arises, apply grievance drainage to your mind. Point it to someone you trust until not a vestige of it remains within you. Then forget it.

Those who perfect the "try" technique may not be endowed with brilliant talent, but they go places in life because they become indomitable and undefeatable competitors.

The problems you have, the more alive you are!

You will get results directly in proportion to the faith that you have and use.

If power is not coming through, find the block and remove it.

Worry rolls off the composed mind like water off a duck's back.

Sing at least one song every day.

The Spirit of God can revitalize every great thing.

You can make the mind give you back anything you want, but remember the mind can give back only what it was first given. So fill your mind with all peaceful experiences possible, and then make planned and deliberate excursions to them in memory.

In every difficult situation is the potential value. Believe this, and then begin looking for it.

Take the bright view that if you do your part, the very best you know how, always think, and work positively, bountiful supply and abundant living will come.

Say aloud, "I don't believe in defeat", until the idea dominates your subconscious attitudes. You will receive the power to handle all your problems.

Fear is the most powerful of all thoughts with one exception and that one exception is faith.

Miracles are not altogether made out of dreams. Often they are put together out of plan, everyday non-glamorous facts.

You can become free of worry by practicing the opposite and stronger habit of faith, with all the strength and perseverance you can command, start practicing faith.

There is nobody who has a problem for which there is not an answer through wisdom and the guidance of God.

Keep exercising your mind. Think health—always think health.

Always be on the lookout for the big idea that can change your life.

Know there is no death…that all life is indivisible… that the here and hereafter are one… that time and eternity is inseparable… that this is one unobstructed universe… that we are citizens of eternity.

Each if us has good news deep within ourselves—the fact that with God's help we have what it takes to meet all upsetting situations and to react creatively to them.

If you have lost confidence in your ability, to win, make a list, not of the factors that are against you, but of those that are for you. Say aloud, "I don't believe in defeat", until the idea dominates your subconscious attitudes. You will receive the power to handle all your problems.

Life's blows cannot break a person whose spirit is warmed at the fire of enthusiasm.

…If you feel afraid, you make yourself courageous by acting courageous… If you are feeling unhappy, by deliberately acting happy you can induce happy feelings... If you are lacking in enthusiasm, by simply acting enthusiasm, you can make yourself enthusiastic.

Let go and let God. Let Him take over your life and run it. He knows how.

For the next twenty-four hours, deliberately speak hopefully about everything; about your job… about your children's marks in school… about your health… and about your future.

There is nothing at all wrong with having money, unless money has you.

If you want to get somewhere, you have to know where you want to go and how to get there. Then never, never, never give up.

Live your life and forget your age.

When you become detached mentally from yourself and concentrate on helping people with their difficulties, you will be able to cope with your own more effectively. Somehow, act of self-giving is a personal power-releasing factor.

To keep motivation going strong, begin at once the mental practice of seeing yourself as an altogether new individual— one who is always vital, vigorous and excited.

Never use the word "impossible" seriously again. Toss it into the verbal wastebasket.

When you expect the best, you release a magnetic force in your mind by a law of attraction that tends to bring the best to you.

You can make your life what you want it to be through belief in God and in yourself.

You will always get an idea if you think and do not panic.

Drop the idea that you are Atlas carrying the world or your shoulders. The world would go on even without you. Do not take yourself so seriously.

Stamp indelibly on your mind a picture of yourself as succeeding. Never permit it to fade. Your mind will seek to develop this picture.

For health and vitality, keep affirming that the powerful life force of God is flowing through your mind, your spirit and your body.

The minute your feelings are hurt, do just as when you hurt your finger. Put some spiritual iodine on the hurt at once by saying a prayer of love and forgiveness.

The tough-minded optimist views any problem as a challenge to his intelligence, ingenuity and faith. He keeps on…thinking…praying and believing. He knows there is a solution and so he finally finds it.

Self-trust is the first secret of success. So believe in and trust yourself.

Right eating, right exercising, right thinking, right praying, right living—these tone up vitality.

Know that with God's help you take what you have courageously and victoriously.

Start and end every day, and in between times, too, by thanking God for everything.

Enthusiasm lifts living out of the depths and makes it mean something. Play it cool and you may freeze. Play it hot and even if you are burned, at least you will shed warmth over a discouraged and bewildered world.

---------------------------------Practice hope. As hopefulness becomes a habit, you can achieve a permanent happy spirit.

Forget yourself! Think courage.

Throw your heart over the bar and your body will follow.

Joy increases as you give it, and diminishes as you try to keep it for yourself. In giving it, you will accumulate a deposit of joy greater than you ever believed possible.

Prosperity is not always or even usually to be conceived in terms of money, but as a constant flow of God's blessings.

Life has an "if" at the centre of the world and of our existence as well. Assume control of those variable and uncertain, "ifs".

If everyone followed the purposes of the Creator, the general thrust of life would be in favor, though not without some hard going at times.

Believe it is possible to solve your problem. Tremendous things happen to the believer. So believe the answer will come. It will.

Problems are to the mind what exercise is to the muscles; they toughen and make strong.

You can make yourself sick or well by the habitual thoughts you think. Don't drain back into your body the diseased thoughts of your mind.

Old unhealthy thoughts can block off inspiration and motivation. Dropping them releases a strong flow of power through the mind.

A major key to success is to throw all there is of yourself into your job or any project. Whatever you are doing, give it all you have.

Enthusiasm is a word meaning "full of God". So to have enthusiasm fill yourself full of God.

Do an unexpected favor for someone and note the look of happy surprise in his eyes. This will fill you with joy.

Realize you are greater than you have ever considered yourself to be.

The great speaker gathers up the hopes, dreams, and needs of the people and sends back upon them inspiration to help them realize those values which they seek.

Take charge of your thoughts instead of allowing them to control you.

Tranquility is one of the most beautiful and melodic of all English words, and the mere saying of it tends to induce a tranquil state.

Make a true estimate of your own ability, and then raise it 10 percent.

The attitude you take toward problems and difficulties is by far the most important factor in controlling and mastering them.

Spiritual commitment is not for old balls, but for people who are "with it".

Never minimize your ability to think your way through any situation.

Practice believing in people; show them that you believe in them.

When you get up in the morning, you have two choices—either to be happy or to be unhappy.

---------------------------------- Keep probing for the tremendous quality built into you that has not yet emerged.

When you pray, ask the Lord to direct you. Ask what to do and how to do it. Then believe what He tells you. Do as He says.

You can get over those big mountains of difficulties by thinking over them.

Keep your mental and spiritual "contact points" cleansed so that God can operate through your mind.

Every day spend some unhurried moments in thinking, actually "seeing" the life force at work in you. Your energy and vitality will continue on and on.

Do not let circumstances defeat you. You can if you think you can.

The positive thinker is a hardheaded, tough-minded, factual realist. He sees all the difficulties clearly—which is more than can be said for the average negative thinker. Such a person sees more than difficulties—he or she tries to see the solutions of those difficulties.

To be more than you are, to do more than you are doing, to achieve higher standards and greater results… such qualities are inherent in each of us.

To keep the magic of enthusiasm working for you, have an eye for the charm and romance of living and practice aliveness.

Get worked up about your job, and you will work your job up. Always poke around a problem, looking for its soft spot, for nearly every problem has one. Then break the problem open and find the solution.

There is only one way to deal with weakness, and that is to turn it into strength.

If you want your situation to be different, perhaps the answer is to become different yourself.

Follow a steady program of renewing and revitalizing you are your positive attitudes. Never allow your reactions to become dull or insipid. Keep them new, fresh, and vital.

In adversity keep motivated, for often the best emerges from a difficulty.

Become a positive thinker. No matter how dark things seem to be or actually are; raise your sight and see the possibilities. They are always there.

Deliberately conceive of God's advice as passing into your mind and that in due time you will "know" what the advice is. If you must have that advice today, you will get it. If you do not need it until next week, you will have it then, if you believe you will.

Never forget that marriage is not a contest of wins, but an equal partnership in which each must share and share alike the rewards as well as sorrows.

Remember that you will never be spiritually blessed until you forgive. Goodwill cannot flow toward you unless it flows from you.

Every day practice emptying your mind of all unhealthy attitudes.

It is a well-defined and authentic principle that what the mind profoundly expects it tends to receive. Perhaps this is true because what you really expect is what you actually want.

Realizable objectives are always formed mentally before they are actualized in fact.

One of the greatest techniques of human well-being is surrendering yourself to the recuperative power of God.

Faith power in the mind like adrenaline in the body, can release amazing power within you in crisis.

The way to have a good idea is to have many ideas. So think first, judge later.

When trying makes you stale, divert your mind, relax, and break the strain. Ideas will start flowing again.

Always depend upon the calm knowledge that you can be master of anything that may happen to you.

When you whole-heartedly adopt a "with all heart" attitude, and all out with the positive principle, you can do incredible things.

Do not be afraid to be afraid.

Never talk defeat. Use words like—hope—believe—faith—victory.

The great secret of getting what you want from life is to know what you want and believe you can have it. Always do something for others, and then ask God to help you and get at it.

Thoughts of the same kind have a natural affinity, while the negative thinker tends to draw himself negative results, the positive thinker activates the world around him positively.

If you think lack, you tend to create a condition of lack. Shift your thought pattern to one of abundance and believe

that God is now in the process of giving you the abundance you need.

It is of practical value to you to learn to like yourself. Since you must spend so much time with yourself, you might as well get some satisfaction out of the relationship.

One of the few greatest satisfactions of this life is to handle problems effective and well.

The mind, ever the willing servant, will respond to boldness, for boldness in effect is a command to deliver mental resources.

Take pleasure in the pattern of sunlight falling through the tree or the sound of the crunch of snow under your foot. Relish these things which are the essence of life and they will make your heart sing within you.

Change yourself and your work will seem different.

You have not only the right but also the duty to be happy and successful.

Tell yourself that you like your work. This will tend to make it a pleasure instead of drudgery.

Practice word therapy—serenity, civility, patience, equanimity, Say those powerful, mind-healing words to yourself every day. Let them recondition your stressful attitudes.

Stand up to your obstacles and do something about them. You will find that they have not half the strength you think they have.

Take all the fuming and fretting of the media with a grain of salt. Much of today's news is not new. Most of it has happened before and before that.

Break the tension of a problem by shifting your thoughts completely from it. Instead, think only about God. When you return to the problem your insight will sharpen, your understanding deeper.

---------------------------------It is not always necessary to say words when you pray. Spend a minute just think about God. Think how good He is, how kindly He is, that He is right by your side guiding you and watching over you.

Thinking positively about abilities tends to release positive mental forces that produce effective action.

By acting as you, wish yourself to be, in due course, you will become as you act.

Tackle life with abandon. Go all out, hold nothing back. Self-confidence will draw results.

If you want to stand out, do not be different; be outstanding.

There is no shortcut to any place worth going.

Vitality shows not only in the ability to persist, but also in the ability to start over.

Accept challenges, so that you may feel the exhilaration of victory.

Excellence is not a skill. It is an attitude.

Laughter is the closest distance between two people.

The true sign of intelligence is not knowledge but imagination.

Freedom is not worth having if it does not include the freedom to make mistakes.

Change is difficult but often essential for survival.

Life is ten percent what happens to you and ninety percent, how you respond to it.

Your vision will become clear when you can look into your own heart.

Boldness has genius, power and magic in it.

Our attitude toward life determines life's attitude toward us.

Be bold and mighty power will come to your aid.

Winning is not everything. It is the only thing.

Life is for living. Moreover, living is hopefully more than just surviving. Living is about being playful, curious, and spontaneous. It is about striving for goals, learning from our mistakes, falling in love, falling out of love, and doing dumb things that are part of life's lessons. Life is for growing

stronger and wiser, learning to be useful, trying to make a difference.

Your life goals are always about how you would like to relate to others, to our society, and to the mysterious cosmos, that contains you.

There is always a divine purpose for whatever happens to us—whether positive or negative.

People do great things because they first think they can.

Life Lifters
Part 2

Short and scriptural messages of inspiration and edification that will give your life supernatural lifts daily

DO NOT FEAR OLD AGE AND DEATH

"And all the days that Adam lived were hundred and thirty; and he died" [Gen.5:5]

The physical body, the mortal house that your soul, the real you uses as you live and work in this world will, like all material substances, gradually wears out. Then you will move into another "house" in which the laws of materiality do not operate. Thus, we have much to look forward to. Following God's laws, we are building now our spiritual 'house' for eternity

GOD HAS HIS EYES ON YOU

"Hagar thought, 'Have I really seen God and lived to tell about it?'. So from then on she called him "God who sees me"". [Gen.16:13].

Let God's words sink deeply into your consciousness and the experience of God's protection will be yours. How your spirit will raise as the sublime truth grips you that nothing in this world can hurt you. God is watching over you to keep you in all your way. His amazing kindness surrounds you always. You go through life with a high-hearted spirit. God watches over you.

YOU ARE NEVER ALONE

Wherever you go, I will watch over you, then later I will bring you back to this land. I won't leave you—I will do all I have promised. Gen.28:15]

Uncertainties can be frightening, but these reassuring words show that God will be with you wherever you go or in whatever situation you find yourself. You are never alone. He will always see you through.

NO MORE APPREHENSION—ONLY CONFIDENCE

"Jacob's sons agreed to do what the king had said. And Joseph gave them wagons and food for their trip home just as the king had ordered. [Gen. 45:21]

If we do our part, and live right, and have faith, God will see that all our real needs are supplied. God has infinite riches, enough for all of us. We can receive these through God's law of boundless supply. Live according to His principles and we will never look in vain for any necessity. How the Spirit rises when one develops confidence that he will be cared for, that all will be well, that the future is bright with promise [of God].

SEE GOD'S GOOD IN DIFFICULTY

The LORD said, 'I have seen how my people are suffering as slaves in Egypt, and I have heard them beg for my help because of the way they are being mistreated. I feel sorry for them, and I have come down to rescue them from the Egyptians'. Exo.3:7, 8

God is trying to make us into His people. The father who truly loves his children will not refrain from punishing them when that is necessary to make those children stronger and wiser. So when difficulties come, even painful ones, humbly receive them as a sign of God's deep favor. And remember if we are wounded He binds up and heals. God loves us like that; it is a love greater than anything we will ever know.

NO MORE HUNGER OR THIRST

The Lord answered, "take some of the leaders with you and go ahead of the rest of the people. Also take along the walking stick you used to strike the Nile River, and

when you get to the rock at Mount Sinai, I will be there with you. Strike the rock with the stick and water will pour out for the people to drink". Moses did this while the leaders watched". *Exodus 17:5,6*

The body must have food and water to live. Bread and water, are symbols of deepest longing of mind and soul. Until that hunger and thirst are satisfied, there can be no deep peace or joy. As Alfred Noyes said "I am full-fed, yet I hunger". When we surrender and truly accept Him by faith as Lord then mind and soul hunger and thirst will be deeply and perpetually satisfied. Jesus Christ satisfies.

REST IN GOD

So even though the LORD had threatened to destroy the people, he changed his mind and let them live. Exo.32:14

Many people are lacking in energy. Their vitality is low. They are filled with inner conflicts, which dissipate energy. They are dull and apathetic. What is the secret of energized life? Christ is the answer. It is said of him, "In Him is life" {John1:4} Fill your mind with Christ, fill your heart with Him, and inevitably, energy, vitality, exuberance, delight and eagerness will well up within you.

GETTING RID OF BAD THOUGHTS

The Lord told Moses what the people must do when they commit other sins against the Lord; You have sinned if you rob or cheat someone, if you keep back money or valuables left in your care, or if you find something, and claim not to have it; when this happens, you must return what doesn't belong to you, and pay the owner a fine of twenty percent. Lev.6:1-5

If you are not getting answer to your prayers, check yourself very thoroughly and honestly as to whether you have resentments in your mind. Spiritual power cannot pass through a personality where resentment exists. Hate is a non-conductor of spiritual energy. I suggest that every time you pray, you add this phrase, "Lord, take from my thought all ill will, grudges, hates, jealousies". Then practice casting these things from your thoughts.

FORGIVENESS AND HEALING FOR YOU

You must celebrate this day each year—it is the Great Day of Forgiveness for all sins of the people of Israel. Moses did exactly as the Lord had commanded. Lev.16:34

The destructive forces of sins and disease do not necessarily go together—but sometimes they do and then they cause real trouble. Some spiritual persons, of course, suffer diseases in which sin is no factor at all. God promises healing from both iniquity and diseases. Those who accept true forgiveness are saved from the destruction of the soul. In addition, those who are healed of disease attain that wholeness which God desires for each of His children.

THE LORD WILL WALK AMONG YOU

I will walk with you—I will be your God and you will be my people. I am the Lord your God, I rescued you from Egypt, so that you would never again be slaves. I have set you free; now walk with your heads high Lev.26:12, 13

Here is a mental stimulus of tremendous power, which if received and retained in your consciousness will give you courage to overcome every difficulty. Nothing can ever dismay you. You may question whether mere words can

accomplish so great a result, but never minimize the creative force of an active idea. A mental concept has more voltage than electricity; civilizations are changed by ideas. Emerson said, "Beware of an idea whose time has come"

DIVINELY INSPIRED BLESSINGS

The Lord told Moses, 'when Aaron and his sons bless the people of Israel, they must say: I pray that—The Lord bless and protect you—and that he will show you mercy and kindness—may the Lord be good to you and give you peace. Num.6:22-26

Today, remind yourself that nothing is too late to be true. Your great hopes can be realized. Your most wonderful dreams can come true. All that you really need, you can have. An incredible goodness is operating in your behalf. If you are living a paltry life, resolve to stop it today. Expect great things to happen. Confidently receive God's abundant blessings. Do not think lack. Instead, think prosperity, abundance, and the best of everything. God wants to give you, his child, every good thing. Do not hinder his generosity.

DIVINE HEALING

Moses obeyed the LORD. And all of those who looked at the bronze snake lived, even though they had been bitten by the poisonous snakes. Num.21:9

God does heal. He does it in two ways; through Science and through Faith. In healing, confession is important, for much illness results from buried resentment and guilt. Confession to a competent counselor releases these poisons, cleanses the mind and soul, thus stopping the passing on of diseases

thoughts to the body. Effectual prayer that is scientific prayer is very powerful. The essence of the technique is confess your faults, pray with kindred spirits even if separated by distance and enthusiastically {fervently} believe.

JOY OF SPIRITUAL FELLOWSHIP

Celebrate Passover in honor of me on the fourteenth day of the month of each year. Number 28:16

One effective way to get your spirit lifted is to arrange for periodic times of spiritual fellowship—to think and talk and pray with a few people who, like yourself, are seeking a deeper relationship with Jesus Christ. This practice will bring you one of the most glorious experiences in life. You will be aware that Jesus Christ is in the midst of such a group and the warmth and uplift this knowledge will bring to your heart is possible to describe.

KNOW GOD AND LIVE

"So remember that the Lord is the only true God, whether in the sky above or on the earth below. Today I am explaining his laws and teachings. And if you always obey them, you and your descendant will live long and be successful in the land the Lord is giving you. Det. 4:39, 40

A physician told me that a large percent of patients did not need medicine; they needed God. Tolstoy said, "To know God is to live". How does one find God? The answer is simple: Det. 4:39, 40, say those words over and over until your mind deeply accepts the facts that God will come into your life when you want him with all your heart. Show me a man who really knows God and I will show you a happy, enthusiastic and vital man.

LIFE'S GREATEST BLESSINGS

"No one in Israel should ever be poor. The Lord your God is giving you this land and he has promised to make you successful if you obey his laws and teachings that I'm giving you today. You will lend money to many nations, but you won't have to borrow. You will rule many nations, but they won't rule you. Det.15: 4, 6

The Scriptures suggests how to obtain the values, which make life rich and full with peace, quietness, material necessities and right relationships. We are told to have God's righteousness or right-mindedness. Develop a right thought pattern. Right thinking governed by intelligence, is positive not negative, unselfish not self-centered, creative not destructive, kindly not hateful. Empty these attitudes and everything that you need for a good life shall be multiplied for you.

THE PROMISE OF DYNAMIC LIFE

"Right now I call the sky and earth to be witness that I am offering you this choice. Will you choose for the Lord to make you prosperous and give you a long life? Or will he put you under a curse and kill you? Choose life! Be completely faithful to the Lord your God, love him, and do whatever he tells you. The Lord is the only One who can give life, and he will let you live long time in the land that he promised to your ancestors Abraham, Isaac and Jacob. Det. 30:19, 20

God, our Creator, is also our Recreator. So long as we are in unbroken contact with God, the life force continues strong within us. But having the power of choice, we may choose life or we may actually turn it off, depending upon how well we maintain spiritual contact. When the life flow from

God is reduced, we run down in energy, health and power. However, the re-creative process or life renewal restores power and energy, and it is not complicated. Simply love God, obey his voice, and cling to him. Then he will truly be your life all the length of days. Of Jesus Christ it was said, "In him was life", Christ gives his own victorious life to all who live sincerely with him. The basic method for constantly getting more out of life is simply to have more life within you.

GOD WILL ALWAYS BE WITH YOU

Joshua, I will always be with you and help you as I helped Moses, and no one will ever be able to defeat you. Long ago I promised the ancestors of Israel that I will give this land to their descendant. So be strong and brave. Joshua 1:5, 6

The greatest fact of all is that God is with us. We are not alone. He will never leave nor forsake us but will protect, guide and comfort us at anytime, anywhere. When the going is hard and you feel insecure and may be fearful, just say this wonderful promise and remind yourself that He is always with you.

CLEAN MIND AND HIGH SPIRIT

The Lord was angry with Israel and said: The Israelites have broken the agreement I made with their ancestors. They won't obey me. Judges 2:20

This Life Lifter tells us that the word of God, when recorded in consciousness and held there can make you clean of all guilt. How? The answer is by forgiveness from wrong thoughts and actions; by changing thoughts of impure to

wholesome thinking; by filling the mind with faith so that one experiences a truly marvelous brain—and soul washing. The ugliness of hate is washed from the mind; all sins are forgiven. The inner cleanliness thus gained is an amazing source of high spirits.

PRAY EXPECTANTLY

Joshua, it is forty-five years ago that the Lord told Moses to make that promise, and now I am eighty-five. Even though Israel has moved from place to place in this as he said he would. Joshua 1:4, 10

To pray successfully, you must employ affirmation and visualization. Form a picture in your mind, not of lack, denial or frustration, or illness, but of prosperity, abundance, attainment, health. Always remember you will receive because of prayer exactly what you think, not what you say. If you pray for achievement, but think defeat, you words are idle because your heart has already accepted defeat. Therefore, practice believing that even as you pray you are receiving God's boundless blessings, and they will come to you.

MORAL VICTORY AND A HAPPY HEART

...and shouted, "Samson, the philistines are attacking". Samson woke up and thought, 'I'll break loose and escape, just as I always do'. He did not realize that the Lord has stopped helping him.

Judges 16:20

We become low-spirited when we weakly give into temptation. Such defeat dulls the spirits, subtracting that keen sense of happiness one enjoys when in full control. The

way to overcome temptation is to sincerely want God's help. Earnestly, ask for it; believe you have it, act as God wants you to. This will make you happy and high-spirited.

LOVE GIVEN RETURNS TO YOU

Then he told her to spread out her cape. And he filled it with a lot of grain and placed it on her shoulder. When Ruth got back to town, Naomi asked her what had happened, and Ruth told her everything. She also said "Boaz gave me this grains, because he didn't want me to come back without something for you.

Ruth 3:15-17

When we are on the "outs" or in conflict with other people, it tends to depress us. Instead, practice kindly affection. Always take a generous, forbearing attitude. Practice being considerate. Put the other person ahead of yourself. Courtesy has amazing power to dissipate ill will. Free your heart of jealousy and resentment. The love you give will return to you, and your spirit will be lifted to new levels.

HOW TO AVOID BAD HAPPENINGS

One day, Samuel told all the people of Israel' "if you really want to turn back to the Lord, then prove it. Get rid of your foreign idols, including the ones of the goddess Astarte. Turn to the Lord with all your heart and worship only him. Then he will rescue you from the Philitines""..1Sam.7:3

The best kind of life comes to those who live with the fear of God in their hearts. By fear is meant awe, respect, veneration. Such persons will try always to know God and

do God's will. That would mean self-discipline, but will result in self-mastery, one of the sweetest satisfactions in life. Such people, although they may experience difficulty and pain, will not suffer evil.

PURE MIND AND PURE JOY

Saul was afraid of David, because the LORD was helping David and was no longer helping him. 1 Sam. 18:12

Depression is sometimes due to evil in thoughts and actions. Restlessness and weariness result. Inner tumult keeps every dirty thing in a state of suspension. The waters of the soul are discolored. No one can experience inner peace until he experiences inner cleansing. Our soul are restless until they find peace in Go; then we know pure joy.

IF YOU DO NOT GET TIRE OF DOING GOOD…

David heard that Nabal had died." I praise the LORD!", David said. "He has judged Nabal guilty for insulting me. The LORD kept me from doing anything wrong, and made sure that Nabal hurt only himself with his own evil. 1Sam.25:39,40.

Evil-doing can be awfully wearisome. In fact it produces a self-disgust that most dissatisfying. And the good way of life has its hard moments too. It is not always easy to stay on a high level. But God renews our hearts and keeps us going and hold us up. He helps us to be strong like eagles soaring upward on wings,[Isa.40:31] so that we shall run and not be weary and finally can walk [when the going is hard] and not faint. Just keep on keeping on in goodness. Stay with it and great blessing shall be yours.

GOD GIVES POWER FOR LIFE

David knew that the Lord had made him king of Israel and that he had made him a powerful ruler for the good of his people. 2 Sam. 5:12

Scarcely any joy equals the realization that you have it in you to meet all responsibilities. This consciousness contributes immeasurably to high spirit and happiness. It is quite difficult, on the contrary, to face each day with a sense of inability and weakness. With such an attitude, life seems too much and profound discouragement sets in. Yet God promises that no matter how awesome your problems, you need have no fear. Certainly, you are not to let anything dismay you, for God says He will strengthen and help you. In fact, He promises he will hold you up and make you adequate for any situation. Accept this great fact and hold it strongly in your consciousness until it sends ruggedness throughout your entire life.

LIVING SUCCESSFULLY

Everyone in Israel was amazed when they heard how Solomon had made his decision. They realized that god had given him wisdom to judge fairly 1Kings 3:28

To live successfully, one must overcome blundering ineptness, the tendency to do and say the wrong thing. One must develop the deft and skillful touch that makes things turn out right. A thing does not go wrong because of some persevere fate. It is more than likely that you lack the right slant, the proper approach. If such is the case, what you need is wisdom. If you let God's seep from your conscious to subconscious mind, it will correct the error pattern within you and gradually endow you with wisdom.

RESTLESS FEELING

The Lord God of Israel had appeared to Solomon two times and warned him not to worship foreign gods. But Solomon disobeyed and did it anyway. This made the Lord very angry. 1 Kings 11:9-10

Every now and then, deep unsatisfied longings well up within us. We may seem to have everything our heart can desire and ought to be perfectly satisfied. Still this vague dissatisfaction spoils our happiness. When you notice such feelings, try to imagine Jesus offering you a drink of cold water—symbolic of the water of life that completely satisfies thirst so that one never thirst again. Affirm that you receive from him the ultimate in soul satisfaction. A deep inner peace will gradually grow upon you.

PRAY IN CONFIDENCE, FOR HE HEARS

But first, let us ask the Lord. 1 Kings 22:5

You can have complete confidence in the Lord and his promises. If you have his mind and talk his language, possess his Spirit, identify with his purposes, have his love in your heart, if you are in his will, he always hears you. And God does always answers prayers. He answers in three ways [1] Yes. [2] No. [3] Wait awhile. In addition, every answer, whatever it may be is for our good as long as we are in his will.

SEEK GOD'S WISDOM

His servants went over to him and said, 'sir, if the prophet had told you something difficult you would have done it. So why don't you do what he said? Go and wash and be cured'. 2 Kings 5:13

Perhaps, today, you have a problem, which has baffled you. Try allowing God's word to penetrate your mind until it becomes a dominating conception, and it will do some important things for you. It will make you understand that there is an answer to every problem, and that God is thinking along with you. It will bring to bear upon your problem that keen and sharp perception of wisdom called insight. If you put every problem in God's hand, ask him to give you the right answer, believe that he is doing just that, and take the guidance that comes; your decisions will turn out right

PRAYER CAN HEAL THE SICK

When Hezekiah heard this, he turned his face to the wall and prayed to the Lord, Remember, O Lord, how I have always tried to be faithful to you and do what is pleasing in your sight. Then he broke down and wept bitterly. 2 Kings 20:2,3

I have personally seen this promise demonstrated many times. People who have been given up upon by doctors, and loved one have been raised up when someone has had enough faith to put them unreservedly into hands of the great Physician. There is tremendous power in the prayer of faith as applied in cases of illness.

THE VICTORY OF THE HUMBLE

And they set themselves in the midst of that parcel, and delivered it, and slew the Philistines; and the Lord saved them by a great deliverance. 1Chron.11:14

The proud and puffed up will have a hard time, for even God resists them. But he who humbly depends upon God will receive a vast strength. Get close to God and God will

be very near to you. Cleanse yourself of evil and get your thinking straight. Humbly admit your fault and ask God for strength, and he will lift you up. Humbly follow him and your life will be good, very good indeed.

NOTHING CAN DEFEAT YOU

Solomon, my son, worship God and obey him with all your heart and mind, just as I have done. He knows all your thoughts and your reasons for doing things, and so if you turn to him, he will hear your prayer. Nevertheless, if you ignore him, he will reject you forever. 1 Chron.28:9

Life goes out of you when overwhelmed and defeated. Get firmly based on spiritual understanding, on faith, goodness. Then nothing can defeat you. Live the savings of Jesus Christ, and become like the wise man who built his house upon the rock against which the storms beat in vain, unshakeable. You can have inner serenity, strength and courage that defile all the storms of life. Christ makes you strong. You can be undefeatable. How your spirit will rise!

HOPE FOR THE FUTURE

If my people will humbly pray and turn to me and stop sinning, then I will answer them from heaven. I will forgive them and make their land fertile once again. 2 Chron.7:14

The fear of world tragedy is deep in people's hearts. They hope and yet they fear. Catastrophe lurks in the dark shadows of impending nuclear war. Is humankind to burrow underground like animals seeking protection? There is a better way. It is to accept God's great promise that if we turn humbly to him, he will hear our repentance and save

us from disaster. He is our hope. As individuals, we must turn to God and thus claim our part in the promise of humankind's salvation.

HE MAKES YOU WHOLE

About this same time, Hezekiah got sick and was almost dead. He prayed, and the Lord gave him a sign that he would recover.

Depression of spirit is often caused by a haunting sense of incomplete and by unresolved conflicts. Jesus Christ, the skillful Physician heals the personality. To experience his healing power, yield to him willingly. Make the first move, however timidly, he will response with the miraculous touch that makes you whole in body, mind, and spirit. How your spirit rises as you gain deep inner sense of wholeness.

COMFORT AND PROTECTION

I have ruled this way, and God will never break his promise to me. God's promise is complete and unchanging; he will always help me and give me what I hope for. 2 Sam 23:5

When trouble strikes, what you want is comfort and protection. You want the strength to stand up to it and meet it. You can have both. Frequently remind yourself that God is with you, that he will never fail you, that you can count upon him, say these words "God is with me, helping me".

This will give you a sense of comfort. New hope will flood your mind. New ideas will come. A new sense of power will be felt. As a result, you will rise above your trouble. When a particular trouble arises, before you do anything else about

it, sit down quietly, think about God's promises and put your full faith in them.

GREAT RESULTS OF FAITH

[Read Ezra 7:1-10]

Here we are promised that our lives can demonstrate God's power and greatness. Ezra, a faithful follower who loved God, asked and it was given to him. Even Jesus Christ did great works of love, mercy, and service, so can we also if we identify mind, heart and soul with him. So amazing is the operation of faith in truly committed believers that anything they ask in the name of Christ will be given. This is, of course, no light or flippant promise. To ask in Jesus' name means complete unselfishness and sacrificial spirit. The name should not be material, save for basic need, but rather spiritual. In this name, we may expect satisfaction of basic requirements. The great secret is to ask for that which he wants us o ask for. In addition, it shall be granted overwhelmingly.

PUT IT IN GOD'S HANDS

[Read Nehemiah 1:5-11]

Your present situation may not be to your liking. Perhaps you are dissatisfied and discouraged. Put the matter in God's hands. If he wants you elsewhere, he will lead you there, providing you are amendable to his will. However, perhaps he wants you where you are. In that case, he will help you to adjust to the situation. He will make you content, even grateful for the present opportunities. Learn the great art of doing the best you can, with what you have, where you are. When you do this, you learn how to reach the better condition, or how to make your present situation a better one.

PROBLEMS CAN BE OVERCOME

[Read Esther 8:14-16]

Trust in God's promises and commandments, is Christ's whole message of love and salvation. Believe these promises, live upon then and you shall have peace and assurance, even if the world is full of trouble. Through faith in him, even if the world is full of troubles and problems, you will be overcoming the troubles and problems. So, regardless of the difficulty, be of good cheers, for victory is yours through him.

HEALING SORROW

I know that my Savior lives, and at the end he will stand on this earth. Job 19:25

Sorrow is a heavy weight upon the spirit. It often causes the one who mourns to feel that life will never again be filled with high and buoyant attitudes. But, life goes on and one must live. Our text above brings healing to the human soul, and gives lift to the spirit.

What a glorious message! Jesus Christ is alive and those who believe in him live. All our losses, our loved ones whom we thought dead are not dead at all, but live and shall forever touch our lives, watching over us with the same love and tenderness.

This gives such a lift to the spirit that one wants to shout from the housetops at the glorious fact that through faith in Jesus Christ, we live. So, when sorrow comes, repeat over this wonderful passage. Moreover, presently the shadows will flee away and light of a new day will dawn.

GOD RESTORES

The Lord now blessed Job than ever; he gave him fourteen thousand sheep, six thousand camels, a thousand pair of oxen and a thousand donkeys. Job 42:12

Possibly life has become difficult—even dismal. You may not be getting zest or thrill out of life. This text will restore the old delight in life. It tells you that you have never seen, nor heard, nor even imagined all the marvelous, amazingly fascinating things that God will do for those who love him, trust him, and put his principles into practice. As you surrender your life to God, every experience of living will grow increasingly more wonderful.

GOOD THIGS COME TO GOOD PEOPLE

[Psalm 1:1-3]

Good people have troubles—there is no doubt about that. But by and large they have their reward too, and on earth as well as in heaven.

Psalm 1 tells us how to ensure wonderful blessings begin by avoiding the company of sinful people. Do not become a cynic. Learn to love God's way. Meditate upon and study his truth until your mind and heart are full of it. Then your life will be blessed with richly creative forces. All things will flow toward you rather than away from you. Your effort will be blessed, and God's bountiful prosperity will be yours. You will live on God's law of supply.

GET CLOSE TO GOD

Keep your eyes on the Lord! You will shine like the sun and never blush with shame. Psalm 34:5

A cure for fear that will absolutely work is to get close to God in your thoughts. He is the only certain, unchanging factor in the world. He will never let you down, nor forget you. If plagued by fear, do what this text says "keep your eyes on the Lord!" That may be done by spending 15minutes everyday thinking about God. You can split this up into 5-minutes periods, but never let a day pass without spending 15 minutes thinking about God. Each day, declare to yourself "I surrender myself and all my problems, my loved ones, my future into the hands of God, and I trust him". Three times every day, thank God for all his goodness. Soon, your life will be filled with God, and emptied of apprehension.

RENEW YOUR HEART

***Create pure thoughts in me and make me faithful again.
Psalm 51:10***

Psalm 51:10 contains a thought that will bring you friends, health, happiness, and success. It can improve your disposition. The word "disposition" refers to the manner in which you are disposed to react to situation and people. If your emotional nature is irrational, crabby, selfish, haughty, it impairs or even destroys your relationship.

The quality of your disposition—depending upon your inner spirit—if you have allowed it to deteriorate, Almighty God, who created you, and recreate and renew in you the fine balance, and the controlled spirit, can restore that vital factor in a good disposition, inner quiet control. Let no day pass that you do not say many times, "create pure thoughts in me and make me faithful"

AN ATTITUDE OF EXPECTANCY

Only God gives inward peace, and I depend on him. Psalm 62:5

One of the most serious and powerful facts in human nature is that you are likely to get what you are expecting. Spend years developing the mental attitude of expecting that things are not going to turn out well, and you are likely to get that result. You create a mental condition that looks for an unhappy outcome. If, on the contrary, you develop and maintain a mental attitude of faith, and expectancy—hoping, dreaming, believing, praying, working—you will create conditions in which every good thing can and will grow. Fill your mind with the power of spiritual expectancy, and God and his good will flow toward you.

THE SECRET OF PROTECTION

Live under the protection of God Most High and stay in the shadow of God All-Powerful. Ps 91:1

This "shadow of All-Powerful" might be described as religious depth. Unhappily, not everyone finds this secret place, but anyone can. It does not require extra wisdom, certainly not any material possession. It requires only deep desire and complete surrender. Live with God daily and you shall enter into the secret place of the Most High, the deepest experience of life.

AFRAID OF NOTHING

Your word is a lamp that gives light wherever I walk. Psalm 119:105

Fear haunts the mind of so many. It is a grievous malady. One verse that helped many is this: Psalm 119:105. Fears always

lurk among shadows. It thrives in darkness. A spiritually darkened mind is breeding ground for terrifying fears. Flood the darkness with light and fears scurry away. Fill the mind with light, and fears are driven off. Fears develop when one feels weak. However, the Lord transmits strength. Result? You are afraid of nothing.

UNLOAD YOUR BURDENS

Praise the Lord! He is good. God's love never fails. Psalm 136:1

A human mind can stand only so much weight. One mental burden piled upon another, unless relief is obtained, will reach the breaking point and cause serious difficulty. Fortunately, you do not need to carry your burdens without resistance. God will help you carry them.

But how is this done? It is accomplished in the mind. Practice thinking that God is actually with you. Tell him about your burdens, and believe that he relieves and assists you. Form a picture of yourself as shifting your burdens to him. He is willing to assume them and is perfectly able to do so. Nevertheless—and this is most important—do not give him just part of them. Moreover, do not take them back. Let God handle them. Leave them with him.

TRUST WITH ALL YOUR HEART

With all your heart, you must trust the Lord, and not your own judgment. Proverbs 3:5

This text will help you avoid a nervous breakdown. It will stimulate your recovery if you have had one. A famous neurologist, a specialist in nervous breakdown, often

"prescribes" this text for his patients. He writes the words on a card and instructs his patients to commit them to memory and repeat them until they are indelibly printed on the subconscious mind.

The cause of much nervous trouble is frustration. Moreover, the antidote to frustration is a calm faith. It will not be found in your cleverness, or in your hard toil, but in God's guidance. The cure of frustration is the belief that God will help you obtain your heart's desire. Trust in God with all your heart and you will be able to keep on working in health and happiness for long years to come.

WHEN ANGER GOES, HIGH SPIRITS COME

A kind answer soothes angry feelings, but harsh words stir them up. Proverbs 15:1

Anger is a depressant of the spirit. So much energy is extended in anger that a person can exhaust his/her spirit. The after-effect of anger is despondency. Anger that simmers and seethes is even more depressing because it permits a constant leakage of energy. Fortunately, there is an effective method for correcting this condition. You will be amazed at the self-control it gives: Proverbs 15:1. Next time you feel anger rising, repeat this verse several times and note the effects. It is one of the best Life Lifters.

LIVE THE JOY WAY

If you are cheerful, you feel good: if you are sad, you hurt all over. Proverbs 17:22

Many are ill because they are unhappy. For this condition we discover a medicine in God's Word; Proverbs 17:22. Joy has

healing value, whereas, gloom is sickening. This is why Jesus so emphatically tells us to rejoice. Learn to live the joy way. Take a hopeful and optimistic attitude. Think happy thoughts, say happy things and put joy into people's lives. The more you do this, the more surely you will keep your spirit high.

FIX YOUR THOUGHTS ON GOD

The Lord gives perfect peace to those whose faith is firm. Isaiah 26:3

If your mind is filled with defeat thoughts, fear thoughts, or resentment thoughts, you are bound to be in a state of mental unrest even turmoil, and there can be no inner peace. This passage advises you to practice thinking about god, to keep your mind "stayed" or fixed, not upon your troubles, but upon God. Keep your mind on God for as many times during the day as possible. This may be difficult at first, for you are unused to spiritual concentration. Practice will make it easier.

THE WORD NEVER GROWS OLD

Flowers and grasses fade away, but what our God has said will never change. Isaiah 40:8

As an old hymn expresses it, "change and decay in all around I see. O thou who changes not, abide with me'. The years pass. Loved ones go on ahead. Paper turns yellow with age. Bloom of youth fades. White hairs come. Changes follow one after the others and we say sadly, "things are not as they were". However, one thing never changes because it is truth; truth is the same yesterday, today and forever. So, let us cleave to that which never fades, never whither—the Word of god that stands forever.

LEARNING TO LISTEN

Pay close attention! Come to me and live. I will promise you the eternal love and loyalty that I promised David. Isaiah 55:3

Many people live on the surface. They miss the most astonishing things. They see and yet they do not perceive things. In addition, the reason is they are not really looking. The same is true about what they hear. They listen with their outer ears. For example, people go to church, but the gospel never penetrates their inner consciousness. That is because people do not listen with all their faculties. They do not lose themselves in it.

However, when one inclines an ear and hears listening as though life is depended upon it, getting every word, letting it sink into the mind by a deep and powerful penetration, then the message falls like a healing potency. Every spiritual disease is killed and that person lives with a new health and strength.

LEAVE IT TO GOD

The Lord said; my people, when you stood at the crossroads, I told you, follow the road your ancestors took and you will find peace. Jeremiah 6:16a

One of the greatest of all techniques of mental health teaches us that when we have done all that we can do about a given matter; we are not to get worried, or be in a panic, or filled with anxiety, but take a calm philosophical attitude concerning it. When you have done all that you can do, do not try to do any more, just follow the path to God's peace. Relax, stop, be quiet, do not fuss about it; you have done everything possible; leave the results to God.

THE REWARD OF ENDURANCE

You can see how I suffer insult after insult, all because of you, Lord. Do not be so patient with my enemies; take revenge on them before they kill me. Jeremiah 15:15

Whoever embarks upon Christian life will have periods of testing. However strong his faith, he will experience down moments. He may see the things he believes in floated. It may seem that Satan, not God, controls human affairs. He will not be spared opposition. He may be criticized, mistreated, misunderstood. The way will be far from easy. When such times come, fall further back on God, pray more earnestly, surrender more completely.

WHEN YOU FEEL DOWN

Those who feel tired and worn- out will find new life and energy; and when they sleep, they will wake up refreshed. Jeremiah 31:25

Jeremiah 31:25, 26 are a true Life Lifter, a strength renewer, when you feel down. Those who feel tired and worn-out will find new life and energy. God is the source of all energy in the sun, in plants and in people. Through the pipeline of spiritual thought, he will pour new energy and strength into you. You will feel it physically, emotionally, and mentally. Imagine our lord touching you. Affirm that he is sending into your being his illimitable strength. Repeat this Life Lifter. You will feel new strength.

DEPTH THERAPY

It is good to wait patiently for the Lord to save us. Jeremiah 3:26

Without a deep inner state of quietness, one becomes prey to tension, worry, and ill health. A song, a sunset, moonlights, the sea washing on a sandy shore; these administer a healing balm. However, they lack power to penetrate the inner recesses of the soul. A profound depth therapy is required to attain healing quietness. A habitual repetition of this text will in time, permeate your personality with a complete sense of peace. When tense or restless, sit quietly and allow these words to pass unhindered through your thoughts. Think of them spreading a healing balm throughout your mind.

GOD'S PEACE MAY BE YOURS

I solemnly promise o bless the people of Israel with unending peace. I will protect them and let them become a powerful nation. My temple will stand in Israel for all time. And I will live among my people. Ezekiel 37:26, 27

If peace of God passes all understanding, so does it defy all descriptions. We can only say that god's peace is an exalted feeling high above fears, irritations, and conflicts. When it enters our hearts, the old haunting fears give way to feelings of courage and confidence. The ineffable peace of God offered by Christ is yours for the taking.

THE CURE FOR STALENESS

Fruits tree will grow all along this river and produce fresh fruit every month. The leaves will never dry out because they will always have water from the stream that flows from the temple, and they will be used for healing people. Ezekiel 47:12

Staleness results from lack of spiritual inspiration. But there is a cure—read Ezekiel 47:12. Anyone who has traveled through a desert area is refreshed when he/she comes finally to the green grass country. What makes the difference? Life giving water. Similarly, the arid human personality becomes as a green pasture when the water of life flows through mind and heart. The soul is restored. It becomes peaceful, and develops new vitality. The spirit rises to new heights.

PRAY EXPECTANTLY

I am your servant, Lord God, and I beg you to answer my prayer and bring honor to yourself by having pity on your temple that lies in ruins…god thinks highly of you, and at the very moment you started praying, I was sent to give you the answer. Daniel 9:17, 23

Daniel prayed expectantly. He had mastered the very practical technique of prayer. It works amazingly. One reason we do not get answer to our prayers is that we ask, but do not really expect to receive. We are expert askers, but inexpert receivers. The spiritual formula of prayer tells us to ask and then immediately conceive of ourselves as receiving. For example, to be free from fear, ask the lord to free you. Then believe that he has immediately done so. The minute you express your faith by sincerely asking him for a blessing and believe your prayer is answered, your prayer is answered.

THE LORD PROTECTS HIS PEOPLE

But I trust the Lord God to save me, and I will wait for him to answer my prayer. Micah 7:7

God's promises mean that no matter what happens, nothing can separate you from his love and protection. The secret is

to build up in your mind, day by day, the knowledge and realization of God's presence—and his love for you. Dwell on this mentally until it becomes an unshakeable fact.

ABUNDANT BLESSINGS FOR YOU

I am the lord All-Powerful and I challenge you to put me to the test. Bring the entire ten percent into the storehouse, so there will be food in my house. Then I will open the windows of heaven and flood you with blessing after blessing. Malachi 3:10

This is one of the most often proved promises of God. In addition, it never fails. Give God his biblical share [at least one-tenth] and he will give you far more than your share. Indeed, he will overwhelm you with blessings. Tithing is the stimulator of prosperity in all aspects of life.

GET RID OF RESENTMENT

But I tell you to love your enemies and pray for anyone who mistreats you. Matthew 5:44

Make a list of all the people who have hurt and mistreated you, or those whom you do not like. Then pray for each by name and sincerely practice forgiving each one. Ask the Lord to bless them. Repel the thought that you are "justified" in your resentment. Then speak kindly about these persons to others. Go out of your ways to help them. This will, in time, breakdown many barriers. But even if it should not, the effect upon you will be amazing. It will clear the path by which spiritual power comes to you.

FINDING REST

Jesus replied; it is because you do not have enough faith! But I can promise you this; if you had faith no larger

than a mustard seed, you could tell this mountain to move from here to there. And it would. Everything will be possible for you. Matthew 17:20, 21.

A mustard seed is very small. So the point of Jesus' promise is that you can do not need a big-well-developed faith to move mountainous difficulties. Just a little faith will do it. But it must be the real thing, the kind that comes by deep desire and earnest prayer. Armed with this thoroughly genuine faith, you can approach those huge difficulties and remove them. That which formerly seemed impossible becomes gloriously possible. But it is not you who will remove big mountains of trouble from your path. It is rather your great faith—mountain-moving, mustard-seed faith. Such faith changes hopeless impossible into wonderful possibilities.

REWARD FOR CHRISTIAN WITNESS

Do not be ashamed of one me and my message among these unfaithful and sinful people! If you are, the Son of Man will be ashamed of you when he comes in the glory of his Father with his holy angels. Mark 8:35

Not all Bible promises are gladsome. Some are pretty challenging, even stern and rugged. The promise in Mark 8:35 is a case in point. It is sharply directed to those who, while committed to Christ at least partially, try to keep it quiet so as perhaps not to disturb anyone or avoid seeming at all different from everyone else. Nevertheless, no person can get away with such a halfhearted devotion for long. Christ insists upon courageous, all-out loyalty, even enthusiastic witness both by speech and action—particularly the latter.

In addition, he promises that if our discipleship is not genuine, he can hardly be expected to witness for us. We must have

the character to stand up for him in this pagan culture. Then he will witness for us at the final accounting.

MOVE YOUR MOUNTAIN

If you have faith in God, and do not doubt, you can tell this mountain to get up and jump into the sea, and it will. Mark 11:23

Almost alone this message can revolutionize your life and change defeat into victory. What does it tell you?

That your "mountain", that great rock-like obstruction, that tremendous barrier, can be broken down and ousted from your life. You must not doubt in your heart. Allow no negative thoughts to exist in your subconscious mind. Pray that your mountainous difficulties shall be removed, and as you pray, believe that it is being done then and now. Do not have the hazy idea that this mountain may be removed sometime in the future, but believe that God is removing it for you now.

SHOWERS OF BLESSINGS

So, I tell you to ask and you will receive. Search and you will find. Knock and the door will be opened for you. Everyone who asks will receive, everyone who searches will find, and the door will be opened for everyone who knocks. Luke 11:9, 10

Our spirits rise when we learn how to receive the abundance of good things God wants to give us. The secret is in two verses; Luke 19: 9, 10. Note that the word ***ask*** is immediately followed by the word ***will receive;*** that directly after the word ***search*** are the words you ***will find***, and that quickly after the word ***knock***, is the assurance that it will be ***opened***

for you. The words emphasize that everyone who *asks, receives*, and everyone who *searches, finds*, and to all who *knocks the storehouse is opened.* Therefore, *confidently ask,* then visualize yourself as now *receiving;* **search**, then affirm that you have *found*; *knock,* then believe that God's *storehouse is opened.* Practice receiving. Believe that you have been given. Then feel your spirit lifted as you realize that God's blessings are actually showered upon you.

THE KINGDOM WITHIN YOU

There is no use saying, 'Look! Here it is or Look!! There it is'; God's Kingdom is here with you. Luke 17:21

When you are filled with self-doubt, and in the grip of your inferiority complex, do not give up saying, 'I cannot do it… I have not it in me'. You do have a very big 'it' within you. You have the Kingdom of God within you. God has placed in your personality all the ability you need. You have only to believe in yourself, and the strength within you will be released. In saying the text, try it this way; "God's abundance peace, and power are within me. I lack nothing".

DO THE IMPOSSIBLE

Jesus replied, "There are some things that people cannot do, but God can do anything. Luke 18:27

This text shows how to do an "impossible' thing. Size up your problem; pray about it, do all you can about it. If it seems impossible, do not give up, but affirm, 'The things that are impossible with humans are possible with God'. Keep relaxed. Do not worry. Avoid getting panicking. Never think, 'this cannot be done'. Declare, 'it can be done; it is being done because god is doing it through me'. The outcome may not be entirely what you desire. Nevertheless,

handled in this manner, the solution will be what God wants it to be.

THE QUICK REWARD OF LOVE

Then he said to Jesus" Remember me when you come into power. Jesus replied, "I promise that today, you will be with me in paradise. Luke 23:42, 43

Through his pain, the dying thief heard the jeer of the crucifying crowd. Pain often sharpens perception. Suddenly, he knew that this noble character on the cross was truly God's Son. He believed and he humbly asked forgiveness and admission to God's Kingdom. No sooner was it asked than it was granted. So, too, when we believe and ask for pardon it will be granted. When our hearts accepted him, Christ admits us to paradise.

THE RESURRECTION AND THE LIFE

Jesus then said, "I am the One who raises the dead to life! Everyone who has faith in me will live, even if they die. And everyone who lives because of faith in me will never really die. Do you believe this?" John 11:25, 26

This promise may be the most profoundly comforting statement ever made. Death of the body is the lot of all humans, but through faith in Christ, there need no death of soul… when the final day comes, put your hand in his hand and go forward unafraid.

THE REFRESHING WATER OF LIFE

But one who drinks the water I give will never be thirsty again. The water I give is like a flowing fountain that gives eternal life. John 4:4

To revitalize the spirit is a necessity. The need is met by an amazing formula: John 4:14. Every longing of the human spirit finds enduring satisfaction in the life-giving message of Jesus. It comes as a perpetual well of self-renewing inspiration. From the water of life, our spirit is endowed with continuous refreshment. We never thirst again.

REFRESHMENT OF SPIRIT

So turn to God! Give up your sins, and you will be forgiven. Then that time will come when the Lord will give you fresh strength. He will send Jesus, his chosen Messiah. *Acts 3:19, 20*

When the rains bring the miracle of earth's renewal, it is indeed, a time of refreshing. A similar process occurs in human life. By wrong thinking and misdeeds, the freshness of mind and soul fades. If we are spiritually changed, "that time will come when the Lord will give you fresh strength". How clean, fresh and delightful life then becomes!

GOD RE-CREATES US

God has done all this, so that we will look for him, and reach out and find him. He is not far from any of us, and he gives us the power to live, to move and to be who we are. "We are his children", just as some of your poets have said. Acts 17:27, 28

Acts 17:27 and 28 are a formula for maintaining physical, mental and spiritual energy. The tension and pressure of modern living draws upon our energies. However, here we have a renewal method. The text reminds us that god created us and creates us. The secret is to maintain contact with God. This brings vitality, energy, and constant replenishment into our being.

Every day, preferably about mid-afternoon when an energy lag usually comes, try repeating this text while visualizing yourself as: plugged' into the spiritual line. Affirm that God's re-creative energy is restoring strength and power to every part of your body, your mind and your soul.

THE PROMISE OF FORGIVENESS

I want you to open their eyes, so that they will turn from darkness to light and from the power of Satan to God. Then their sins will be forgiven, and by faith in me, they will become part of God's holy people. Acts 26:18

The forgiveness of sins is one of the most majestic of all biblical promises. Jesus took upon himself our guilt and atoned or paid with his own physical life for the wrong we have done. It represents God's supreme entreaty; His profoundest appeal to us. The great promise is that if we believe in the atoning power of Christ's death on our behalf, we shall not perish when we die, but have everlasting life.

GOD IS FOR US

What can we say about all this? If God is on our side, can anyone be against us? Romans 8:31

Imagine yourself as actually looking at all your difficulties like an army lined up against you. Then realize you have an ally that can overcome them all. As you face some enemies of yours—discouragements, frustration, disappointment, hostility, weakness—ask yourself, "What shall I say to these things?" In addition, the answer is, "if God is on our side, can anyone be against us?" Now spend a minute realizing that God is for you and say this affirmation; "God is with me. God is for me. God is greater than all these things". Then visualize these enemies of your peace and happiness

retreating, giving way before God's power. Personalize the text by saying; "if God is on my side, can anyone be against me?" The repetitive use of this text will give you an enormous sense of God's presence and a powerful feeling of victory.

FAITH, HOPE AND LOVE

For now, there are faith, hope and love. But of these three, the greatest is love. 1Corinthians 13:13

The top three-point formula for living is in this immortal verse—1 Corinthians 13:13. Here are three powerful Life Lifters. Faith—the greatest power in this world. Hope—the attitude of expectancy—the best is yet to be. Moreover, Love—one of the greatest qualities of all—a heart of compassion and understanding. Christian love gives deep joy. Let these three shine like stars in your life, and your spirit will be uplifted always.

DON'T BE DISCOURAGED ABOUT YOURSELF

Anyone who belongs to Christ is a new person. The past is forgotten, and everything is new. 2 Corinthians 5:17

Never be discouraged about yourself. You may have tried all your life long to rid yourself of wickedness, your obsessions, jealousies, sins and inferiorities, without success. Your failure is probably that you have been trying to hide yourself over. That is a long, tedious and essentially impossible project.

However, it can be done in no time at all by Christ. All you need do is to say to him simply, "Lord, I do not want to be this way anymore", and mean it. He will do for you what you cannot do for yourself—effect a lasting change in you. Ask him to change you.

HAPPY THOUGHTS TRANSFORM YOU

God's Spirit makes us loving, happy, peaceful, patient, kind, good, faithful, gentle and self-controlled. There is no law against believing in any of these things. Galatians 5:22, 23

People often manufacture their own unhappiness by the negative manner in which they think about things. Work with your mind, exercise disciplinary control, and re-start your thoughts for happier living.

Drain the mind by picturing yourself dropping out every destructive thought; every fear; every inferiority feeling. Visualize your mind as completely empty. Then start filling it with thoughts of God, and of Christ, thoughts about every good and pleasant thing. Practice this new habit regularly twice every day, morning and evening, to counteract the older and negative habit of allowing unhappy things to occupy your minds. In due course, unhappy thoughts will not fell at home in your mind, and happy thoughts will transform you.

AN ANTODOTE OF DEFEAT

Christ gives me the strength to face anything. Philippians 4:13

This is an antidote for every defeat feeling. If you feel discouraged by situations, and the going is hard, this statement will remind you that you do not need to depend upon your own strength entirely, but that Christ is with you and is now giving you all the help you need. Teach yourself to believe that through Christ's help you can do all things. As you continue this affirmation, you will actually experience Christ's help. You will find yourself meeting problems with

new mental force. You will carry heavy burdens with ease. Your new "lifting" power will amaze you.

ALL POWER YOU NEED

Christ Jesus came into the world to save sinners. This saying is true, and it can be trusted. I was the worst sinner of all!. But since I was worse than anyone else, God had mercy on me and let me be an example of the endless patience of Christ Jesus. he did this so that others would put their faith in Christ and have eternal life. I pray that honor and glory will always be given to the only God, who lives forever and is invisible and eternal king! Amen. 1 Timothy 1:15-17.

You can possess within yourself all the power you will ever need in life. The method for securing power is very simple and depends entirely upon you. It is to "receive" Christ. When this is sincerely done, you will in turn receive power. Moreover, how do you receive him? Simply decide that you want him, tell him so and mean it. Then, starting today, begin to live on a basis you know he would approve. The essence of the formula is surrender to God's will and Christ's way. It is that acceptance of a new manner of thought and life. Continue to re-surrender yourself every day, and you will feel spiritual power surging in.

FEAR IS OVERCOME BY POWER

God's Spirit does not make cowards out of us. The Spirit gives us power, love and self-control. 1 Timothy 1:7

Your fears can be healed by this text. It tells us that fear is overcome by power. What power? There is only one force more powerful than fear, and that is faith. When fear comes to your mind, counter it with an affirmation of faith.

Secondly, love overcomes fear. By love is meant trust, confidence, and complete dependence upon God. Practice this attitude and fear will diminish.

Thirdly, attain a sound mind in which there are no complexes, quirks and obsessions. Live with the thought of God and you will develop a sound mind where no shadowy fear can lurk. Whenever you are afraid, verbalize against the thing that you fear, using the words of this text.

LOVE LIFE AND HAVE IT GOOD

Remind your people to obey the rulers and authorities and not to be rebellious. They must always be ready to do something helpful and not say cruel things or argue. They should be gentle and kind to everyone. Titus 3:1, 2

For anyone who wishes to enjoy life and experience God's goodness—to be happy, respected and in short live a full, rich life—read slowly but reflectively and humbly the above verses.

In these two verses are listed just a few things that put happiness in your heart. We are reminded to obey the authorities and not be rebellious. We are told to curb our tongues from speaking evil about anyone. Simply never, say anything to hurt anyone. Moreover, we are to refrain from double talk, from shrewd and canny interests at someone's disadvantage. We are to, in every way possible, do good, help people and bring blessings into their lives. We are to become an island of peace in a world of turmoil. Do the simple, honest Christian things. Life will be good and you will love it.

GET UNSWAMPED AND GET A LIFT

Everything belongs to God, and all things were created by his power. Therefore, God did the right thing when he made Jesus perfect by suffering, as Jesus led many of God's children to be saved and share in his glory.

Hebrews 2:10

Being dispirited frequently means swamped by many things. For this unhappy condition, meditate on Hebrews 2:10. The secret is simply to practice the idea that you are a child of God. as such, God will be your guide. He will lend you his strength to augment your own weakness. You can overcome rather than be overcome. Instead of things flowing away from you, they will flow toward you and shall indeed inherit all things. Life will come your way. You will get a great lift of spirit.

WHAT CHRIST DOES FOR YOU

Jesus Christ never changes! He is the same yesterday, today and forever. Hebrews 13:8

We read I the Bible of the marvelous things Jesus did for people, and rather wistfully wish that the same experience might be ours. Through faith in Jesus Christ, they were able to accomplish most astonishing achievements, or were rescued from sad plights, or gained tremendous new power over difficulties. Rather sadly we ask, "why cannot that happen to me?". It can, and as a proof, I urge you to meditate upon this tremendous Life Lifter found in Hebrews 13:8.

The truth stated here is that Jesus Christ never changes. He is an invariable factor in a variable world. He alone, of all people, is not a prisoner of his era. He is just the same now

as when he walked the shores of Galilee. He has the same kindness, the same power to heal and change human lives. He is the same Restorer of courage, the same transformer of men's soul. Anything that he ever did for anyone throughout all history, he can do for you. It all depends upon how completely you surrender yourself to him, and how sincerely you believe.

THE REWARD OF DEFEATING TEMPTATION

God will bless you, if you do not give up when your faith is being tested. He will reward you with a glorious life just as he rewards everyone who loves him. James 1:12.

Temptation is the urge to do or say something wrong, something contrary to the will of God. Moreover, the law of Christ. Temptation often comes in pleasant and seductive forms. Always the mind attempts to rationalize it, to make it seem all right. If we endure and do not give in to evil, we shall truly become master of life, rulers of ourselves. In addition, Christ will help gain victory.

CAST YOUR CARE ON GOD

Be humble in the presence of God's mighty power, and he will honor you when the time comes. God cares for you, so turn all your worship over to him. 1 Peter 5:6,7

In maintaining high spirit, it is important to cultivate the attitude of spiritual surrender. Place yourself, your interests, hopes, and purposes completely in God's hands. If we surrender ourselves to the direction of God being guided by his mighty hand, he will exalt us—help us attain our purposes and rise above all defeats. God cares for you, so turn all your worries over to him. This is a supreme Life Lifter.

GOD WILL FORGIVE ALL YOUR SINS

But if we confess our sins to God, he can always be trusted to forgive us and take our sins away. 1 John 1:9

You carry a heavy burden when sin is in your mind and life. In addition, since sin adds sin, the weight can break you. In fact, many people live needlessly ineffective lives because they will not let go the weight of sin. However, this relief giving promise tells us that if we confess to him our wrongdoing and sincerely ask forgiveness. Jesus Christ will give new life to us. He can be trusted to forgive us and cleanse us from sin.

HE WIPES THE TEARS FROM OUR EYES

They will never hunger or thirst again, and they will not be troubled by the sun or any scorching heat. The Lamb in the center of the throne will lead them to streams of life-giving water, and God will wipe all tears from their eyes. Revelation 7:16, 17.

This is one of the most comforting passages in all literature. It teaches that our loved ones are in a place of peace and beauty. They are under the watchful care of God and regularly experience his tenderness. The deep hunger and thirst of their souls has been satisfied. God like a loving mother puts his protection over them and with a kindly hand wipes away every tears from their eyes. This he has done for your dear ones who have crossed over to the other side. If you learn to love this passage and meditate upon it, he will wipe away every tear from your eyes, also.

THE FINAL GLORIOUS PROMISE

God's curse will no longer be on the people of that city. He and the lamb will be seated there on their thrones, and his people will worship God and will see him face to face. God's name will be written on the foreheads of the people. Never again will night appear, and no one who lives there will ever need a lamp or the sun. The Lord God will be their light, and they will rule forever. Rev. 21:3, 5

In this world where there is so much trouble, so much pain, sorrow, and death, those who believe on him have a tremendous victory promised them. In addition, this victory comes because we are his and he is ours. So great is his love, that he dries away human tears. No more, shall there be death and crying. What a promise! By his vast power, death itself is overcome. Everything becomes gloriously new. This is perhaps the great and ultimate truth, that in Christ and God, everything both in persons and in the world is changed; all becomes fresh, new, and transformed. Thus, the final glorious promise of God's goodness is the triumph of his love over pain and death.

The Book

Life Lifters is an Anthology of words of faith, encouragement, inspiration, and insights for supernatural uplifting on daily basis. You will discover how to develop-

Positive words of faith

Positive confessions

Positive attitude

Positive living

Practical up-lifting

Progressive living

Perpetual joy and enthusiasm

The Author

Jonathan Titilola Olakunle is a Pastor/Teacher/Missionary. He is a Pharmacist and Publisher of inspirational books and Magazines for holistic living. He obtained his Bachelor of Pharmacy

Degree from the University of Lagos in Nigeria, Bachelor of Science [Business Management] from Penn Foster College in Scranton, P.A, USA, Masters of Divinity from the Nigerian Baptist Theological Seminary, Ogbomoso, Nigeria, Masters of Theology and Doctor of Ministry from International Theological Seminary, California, USA.

He is the Dean of Students Affairs and Lecturer at Christ Life Bible Institute and Seminary, Brooklyn, NY, USA. He is President of Entheos Mission Networks—a Teaching, Mission and Evangelistic Ministry based in USA. Jonathan is married to Alice Adenike and they are blessed with four children—Jonathan, Josephine, Joaanah, and Joshua. He lives with his family in Brooklyn New York.